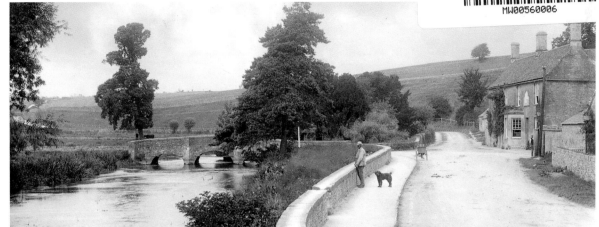

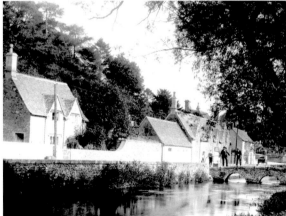

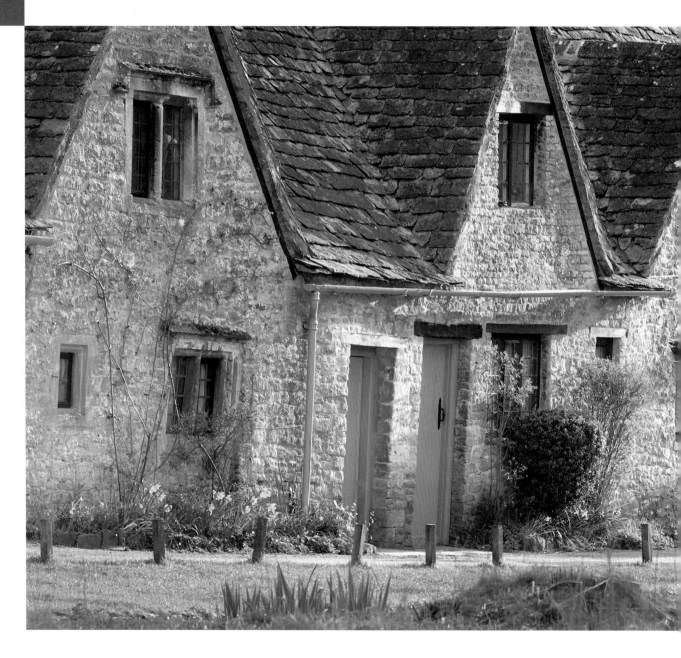

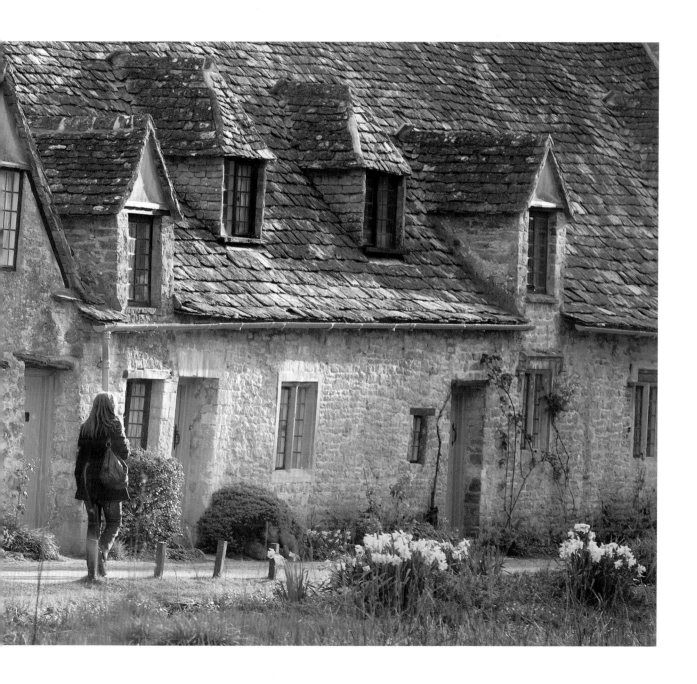

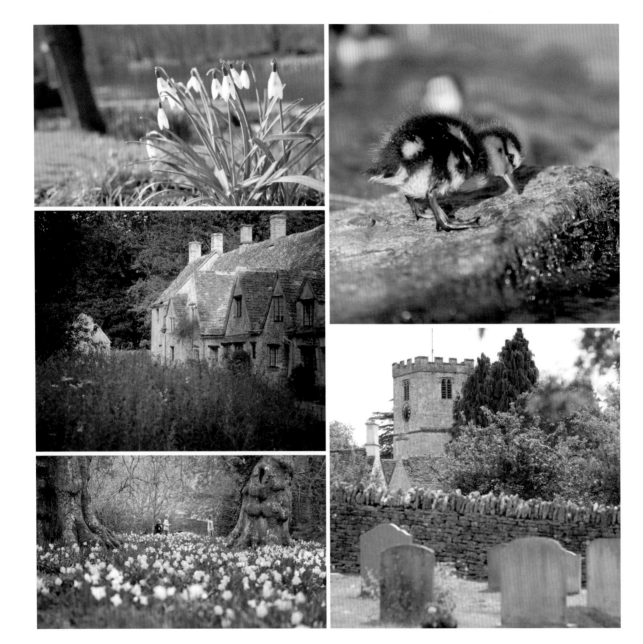

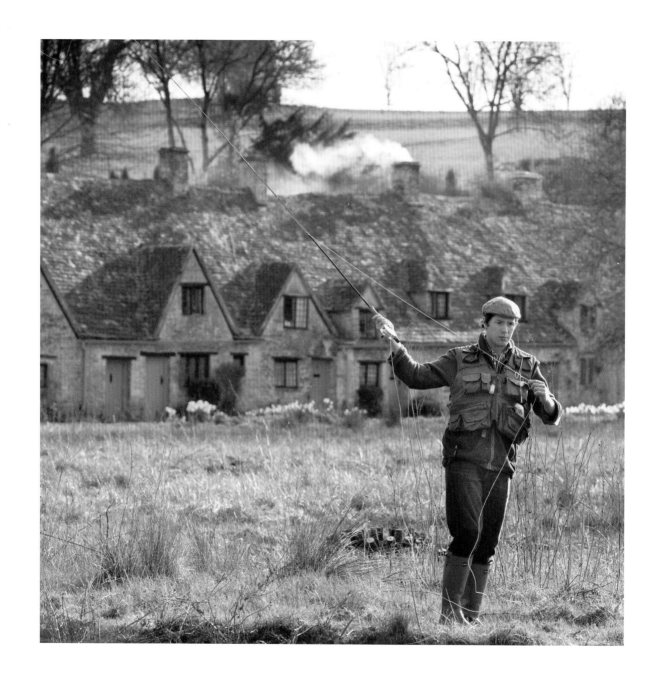

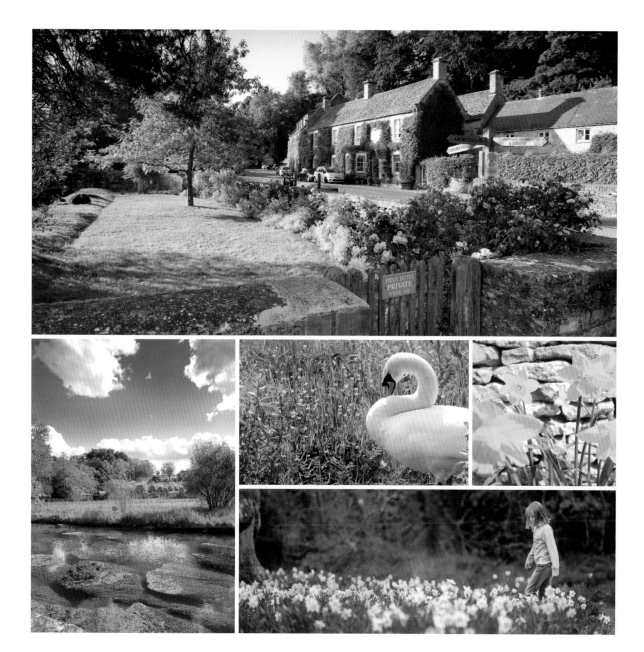

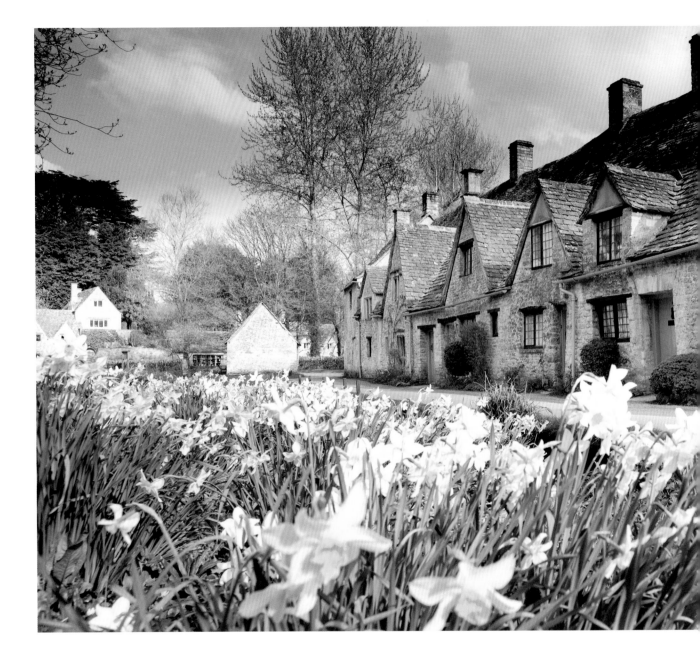

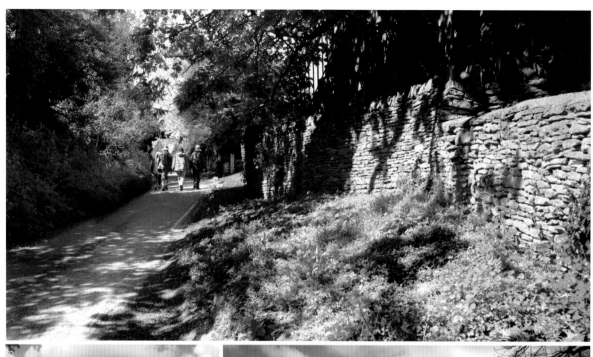

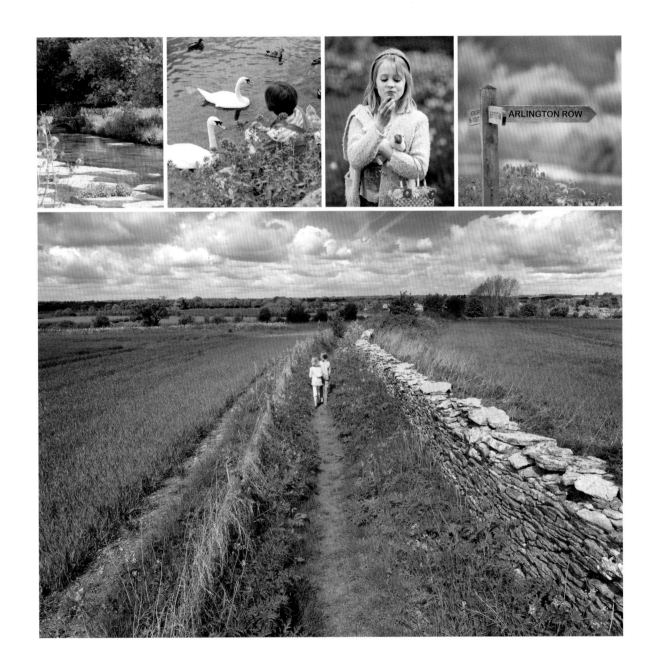

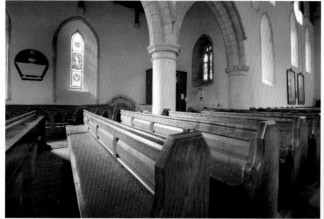

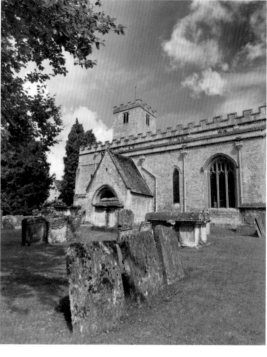

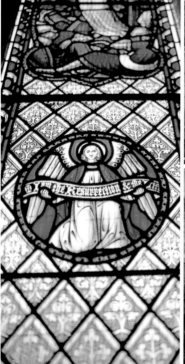

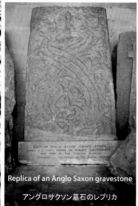

Replica of an Anglo Saxon gravestone

アングロサクソン墓石のレプリカ

St Mary's Church

The Saxon church of St Mary dates back to the 8th century, however much of the Saxon heritage has long since gone, with Norman and Gothic additions throughout the centuries moulding the church into its present form. Some original Saxon artefacts from the site now reside in the British museum and replicas can be seen inside the church. The prosperity of the 17th and 18th centuries is reflected in the impressive wool merchant tombs that can be found within the graveyard.

セントメアリー教会

サクソン朝のセントメアリー教会は8世紀に遡りますが、サクソン朝の遺産はほとんど残っておらず、現在の形になるまで何世紀にも及びノルマン様式とゴシック様式の増築が行われました。サクソン朝のアーテファクトのオリジナルは現在英国博物館に収蔵され、教会の中にはそのレプリカが置かれています。墓地内にある羊毛商人の立派な墓は17世紀と18世紀の繁栄を物語っています。

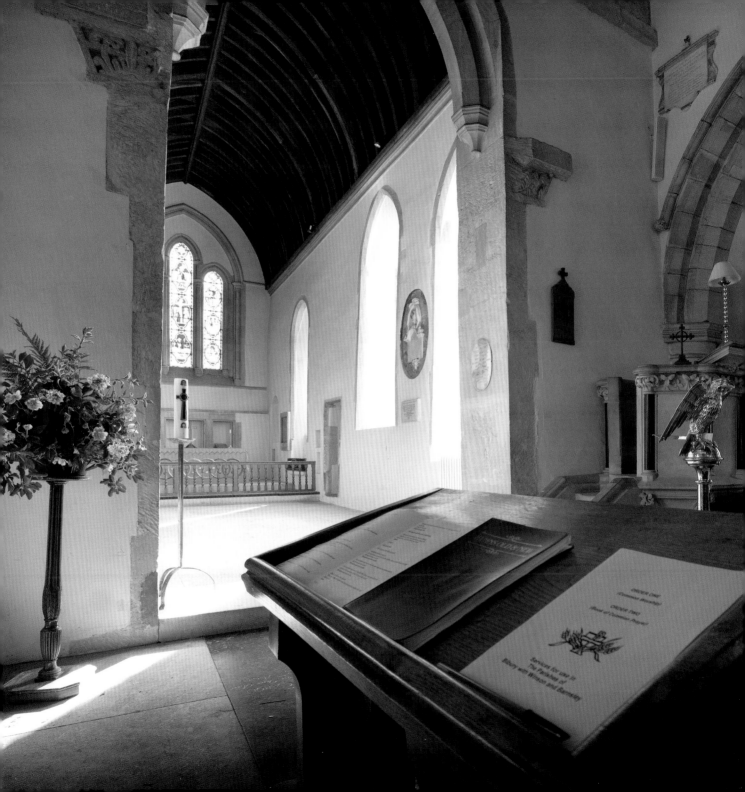

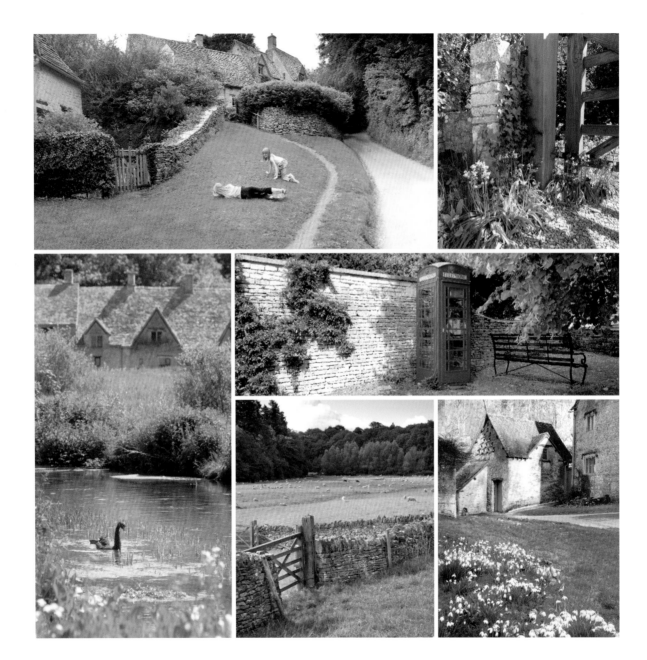

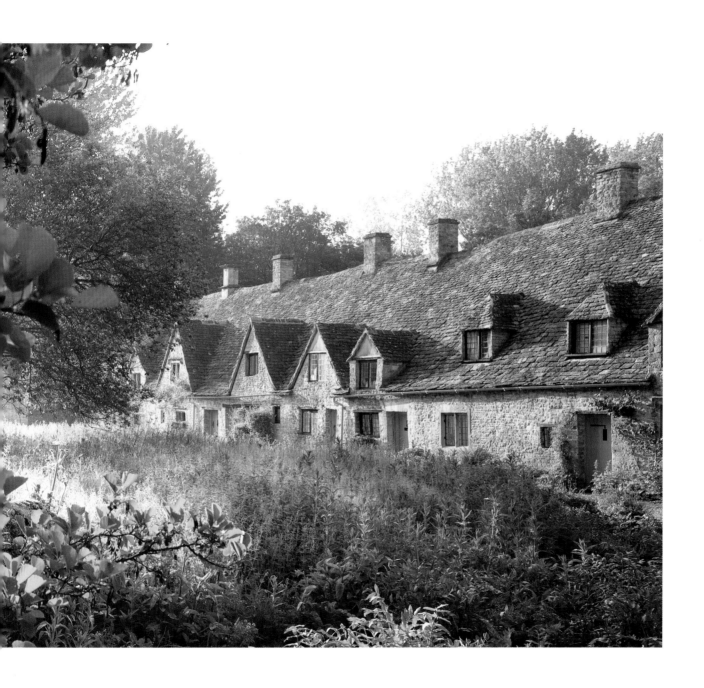

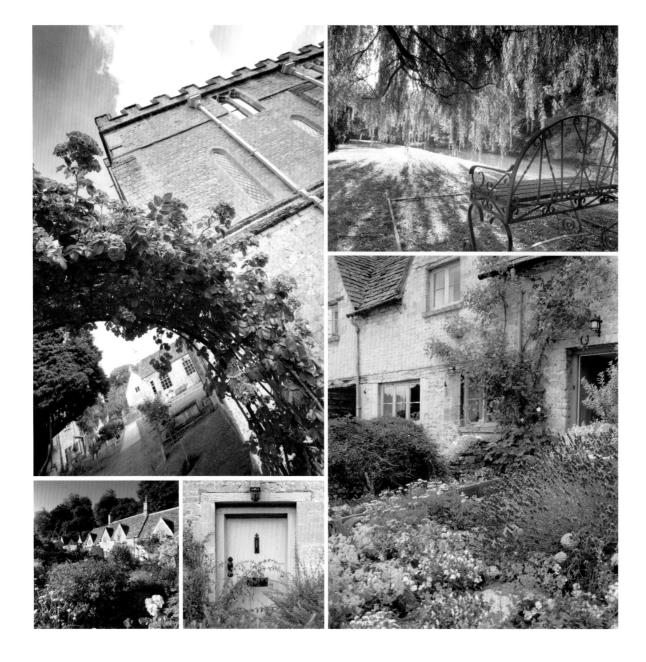

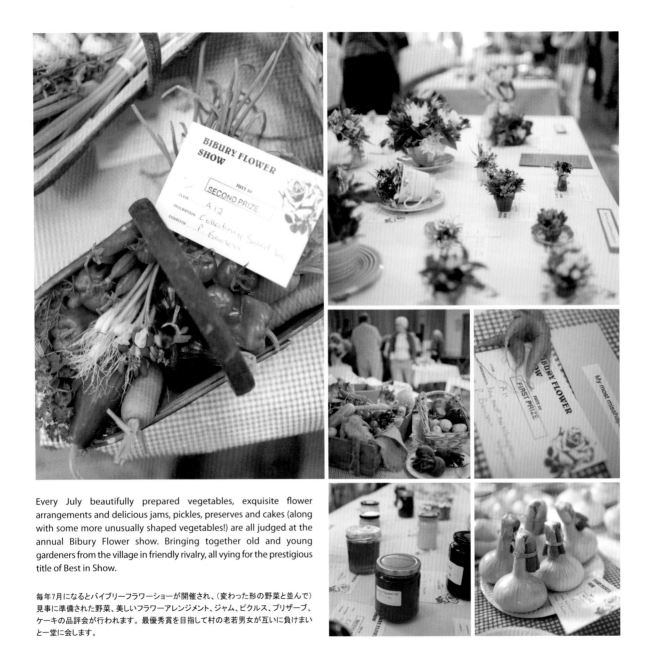

Every July beautifully prepared vegetables, exquisite flower arrangements and delicious jams, pickles, preserves and cakes (along with some more unusually shaped vegetables!) are all judged at the annual Bibury Flower show. Bringing together old and young gardeners from the village in friendly rivalry, all vying for the prestigious title of Best in Show.

毎年7月になるとバイブリーフラワーショーが開催され、（変わった形の野菜と並んで）見事に準備された野菜、美しいフラワーアレンジメント、ジャム、ピクルス、プリザーブ、ケーキの品評会が行われます。最優秀賞を目指して村の老若男女が互いに負けまいと一堂に会します。

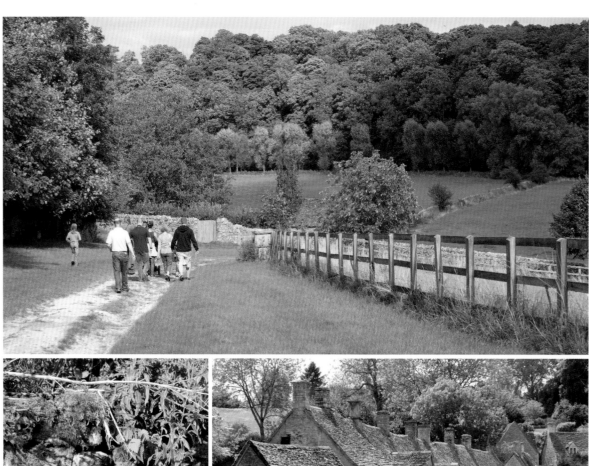

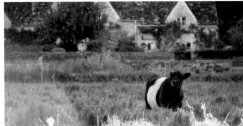
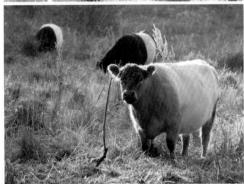
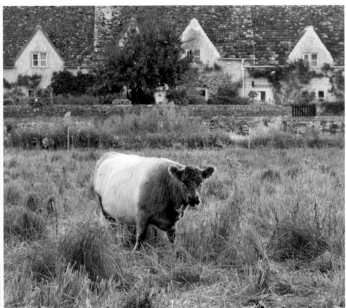

As part of the Cotswolds Grazing Animals Project, Rack Isle is visited annually by Belted Galloway cattle. Their calm temperament and ability to tackle coarser grasses make them an ideal choice to graze Rack Isle. The main objective of this project is to help restore, conserve and enhance flower-rich limestone grassland in the Cotswolds.

The Belted Galloway is a rare breed of cattle originating from Galloway in South West Scotland, which is primarily raised for its quality marbled beef. In America these cows are often known as "police car cows", "panda cows" or "Oreo cows" after the Oreo biscuit.

「コッツウォルズ放牧家畜プロジェクト」の一環としてラック島 には毎年ベルティッド・ギャロウェイ種の 牛が訪れます。その穏やかな気性と粗い牧草をいとわない特質のためラック島 での放牧に最適な牛とされています。このプロジェクトの主な目的はコッツウォルズの花咲き乱れるライムストーンの草原を修復、保存、改善することです。

ベルティッド・ギャロウェイはスコットランド南西部のギャロウェイ原産の珍しい品種で、主に肉用(良質の霜降り肉)に生育されています。アメリカではしばしば「パトカー牛」「パンダ牛」または「オレオ牛」(オレオクッキーに由来)と呼ばれています。

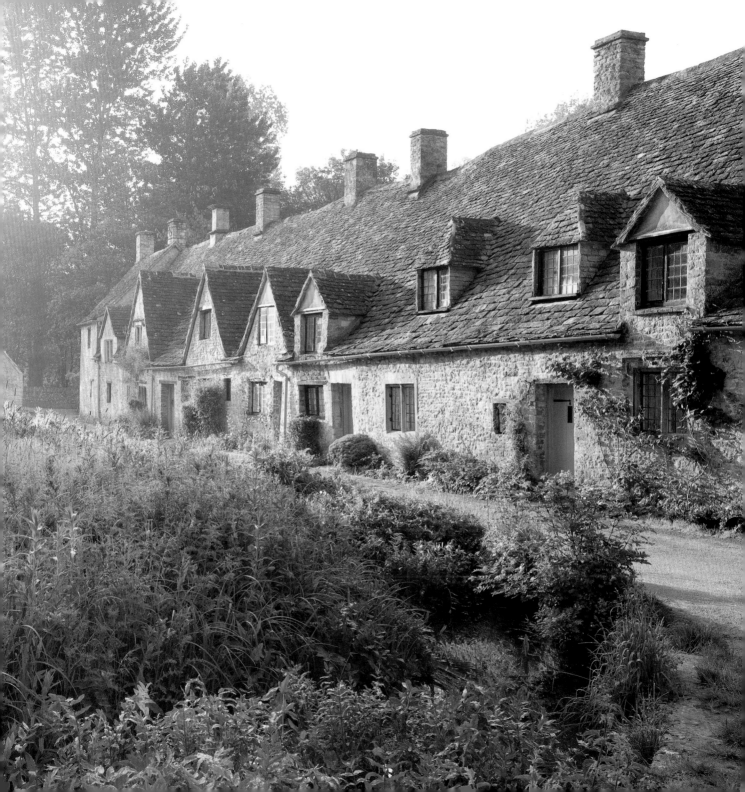

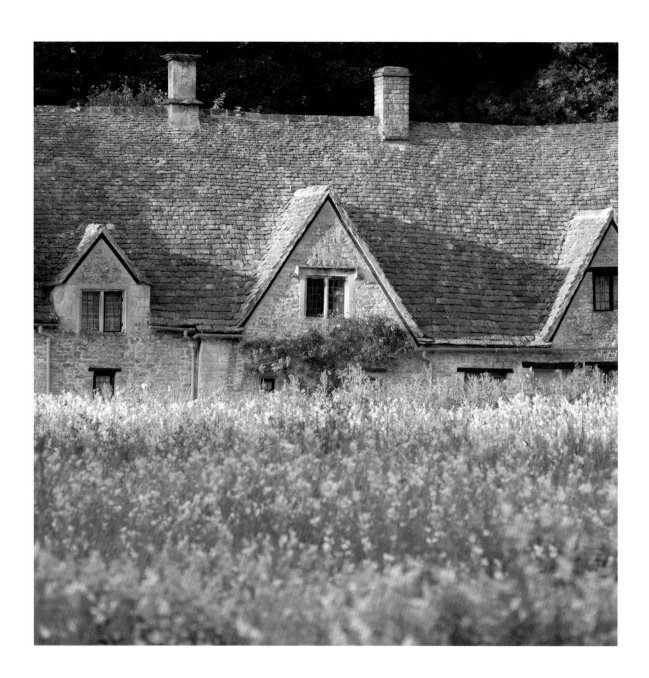

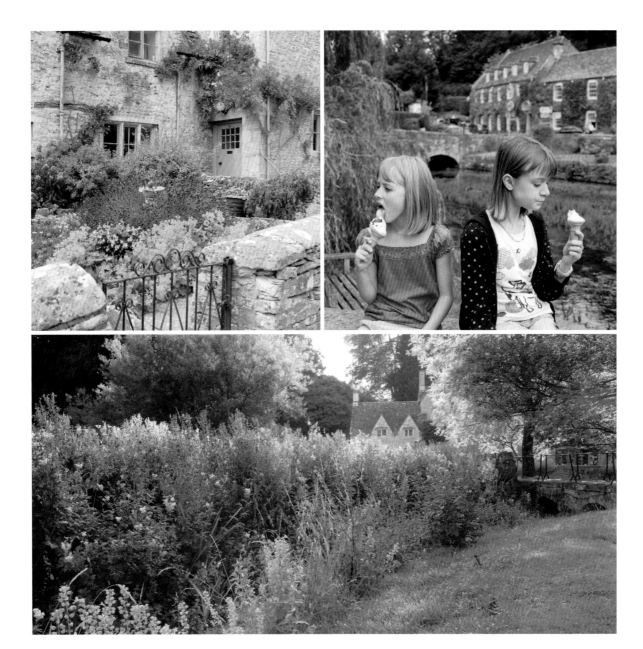

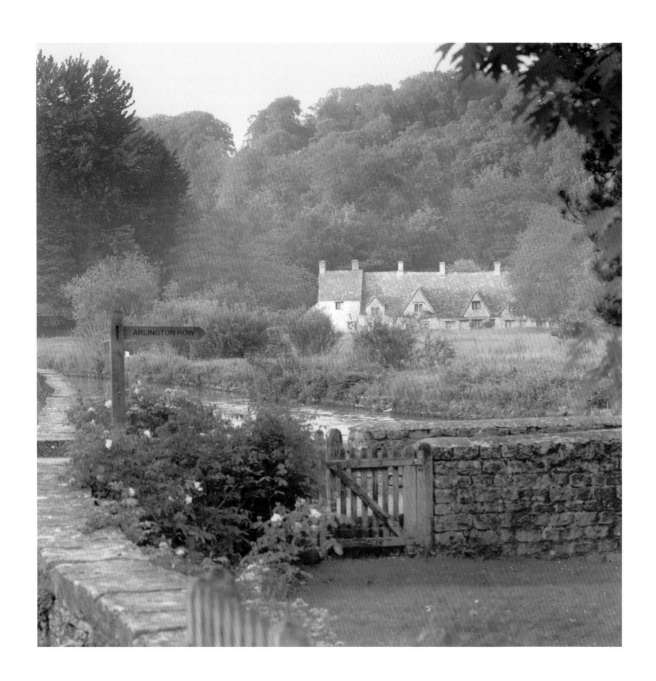

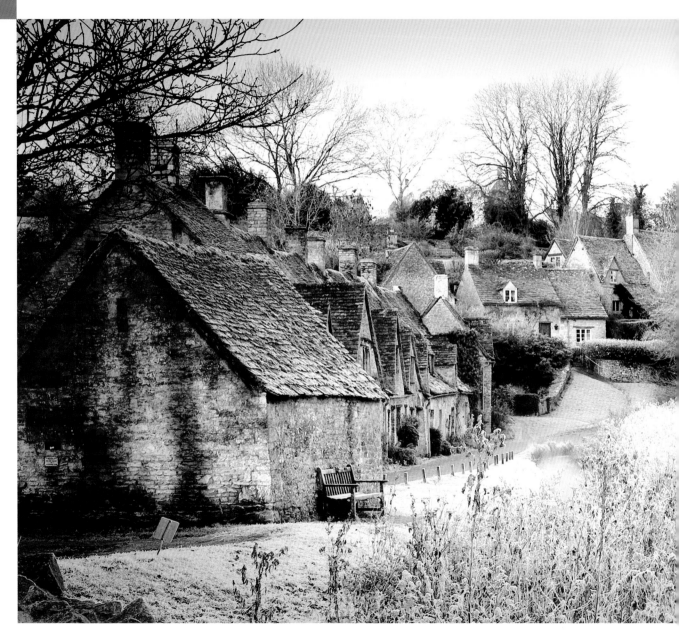

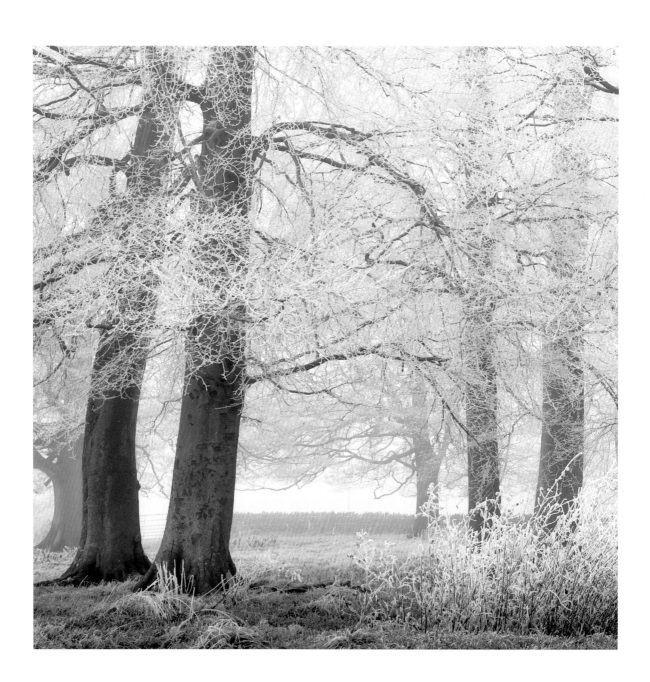

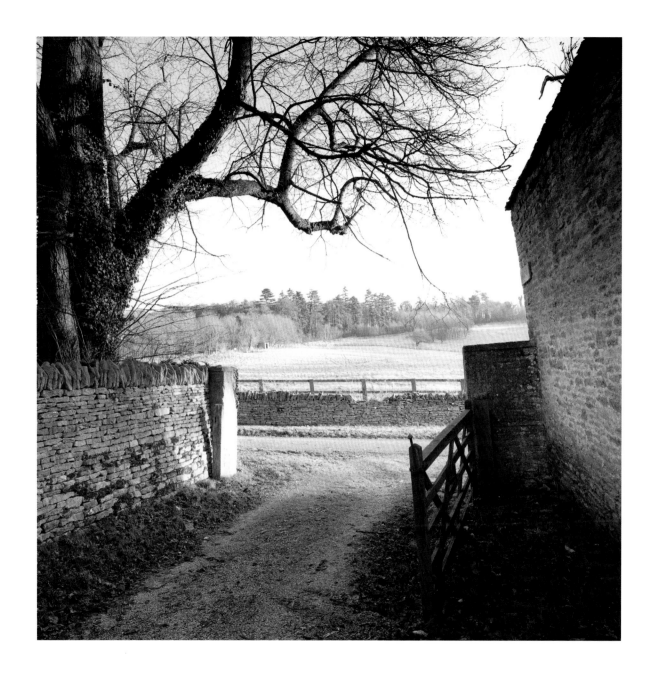

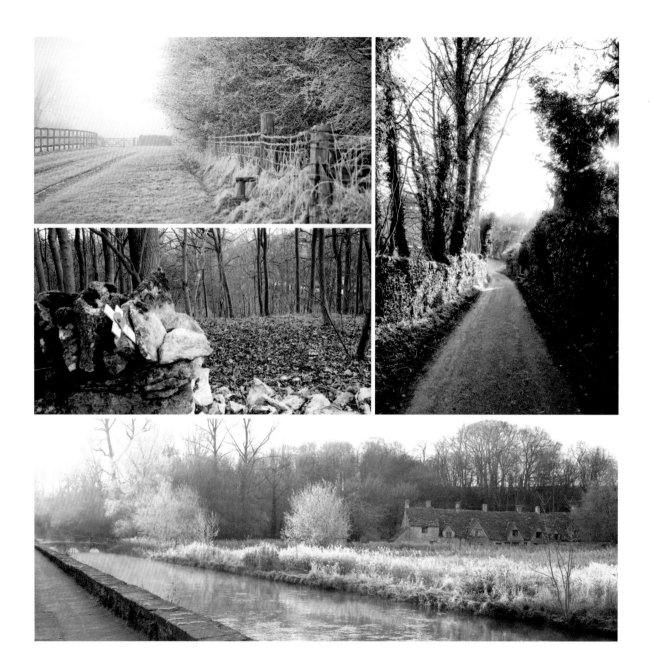

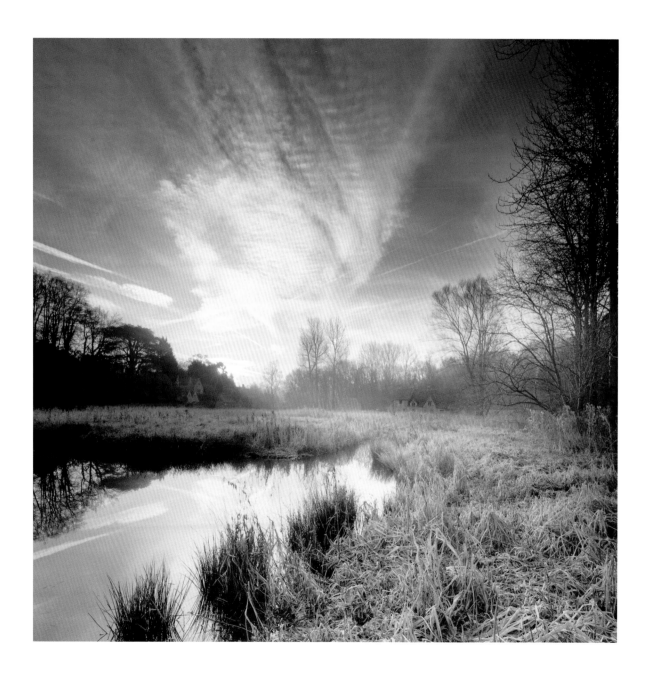

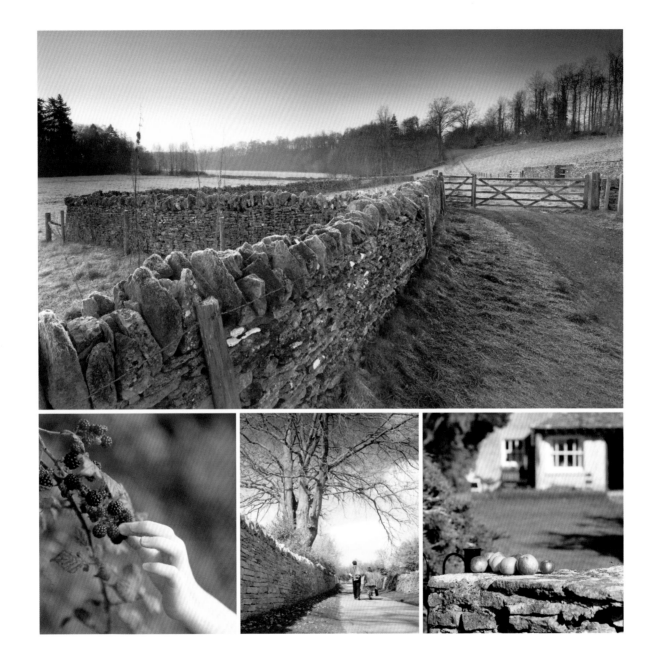

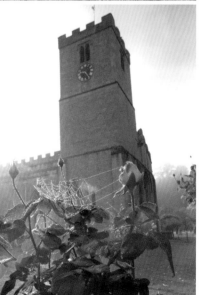

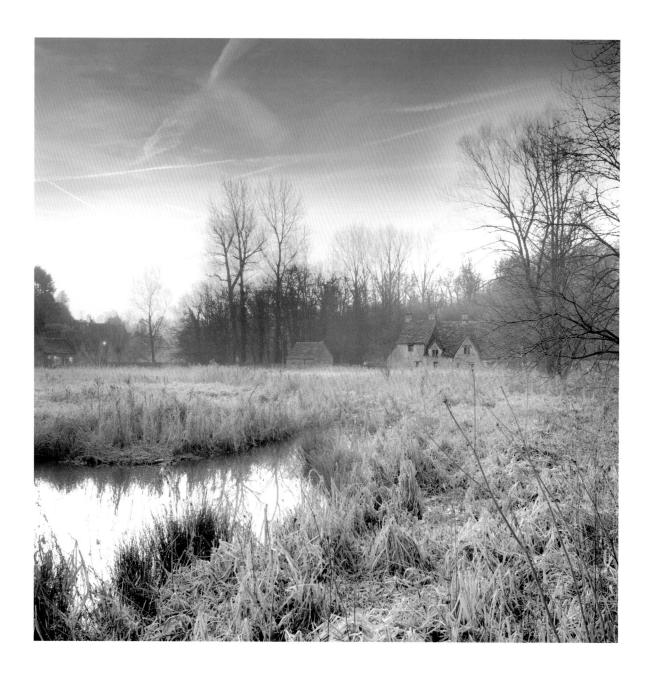

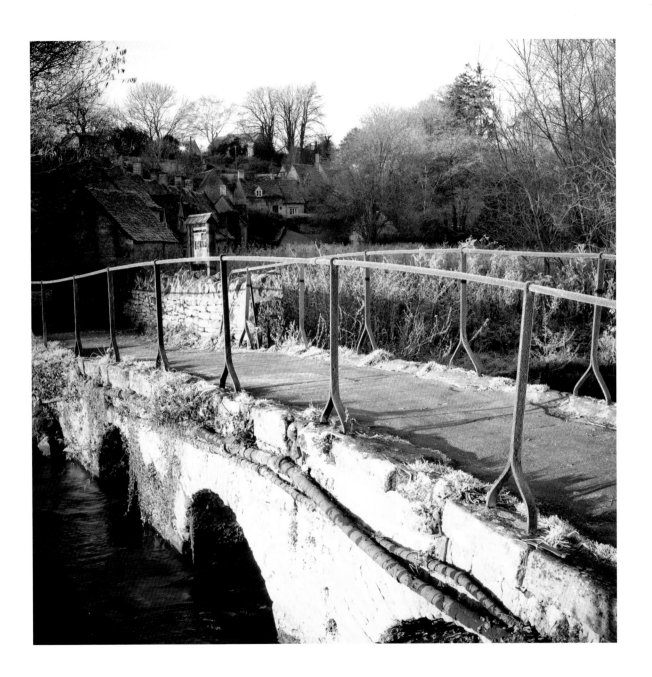

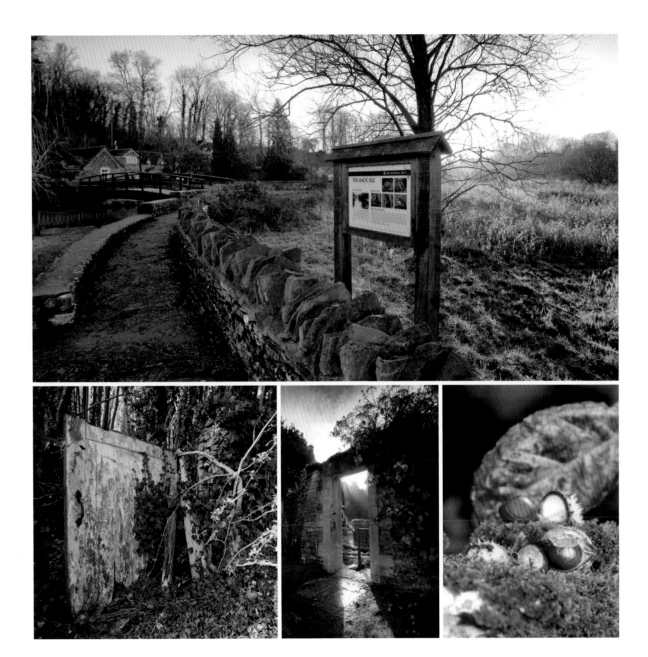

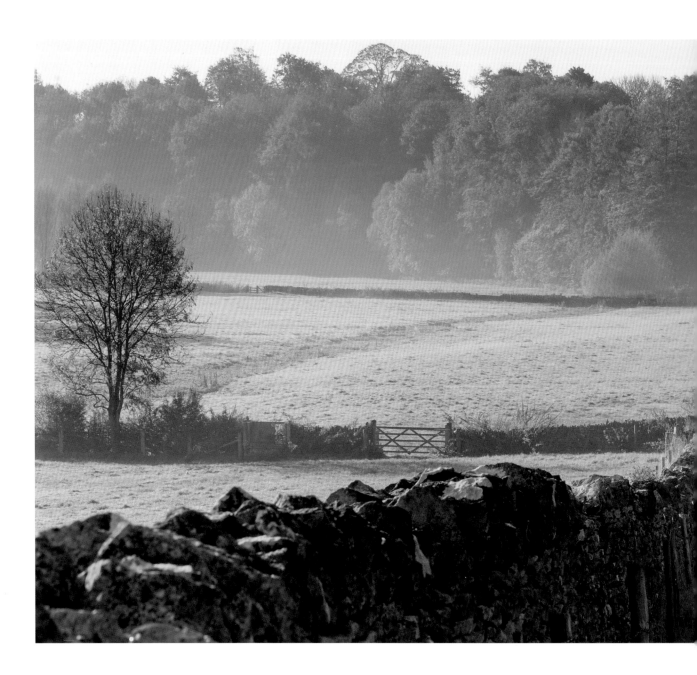

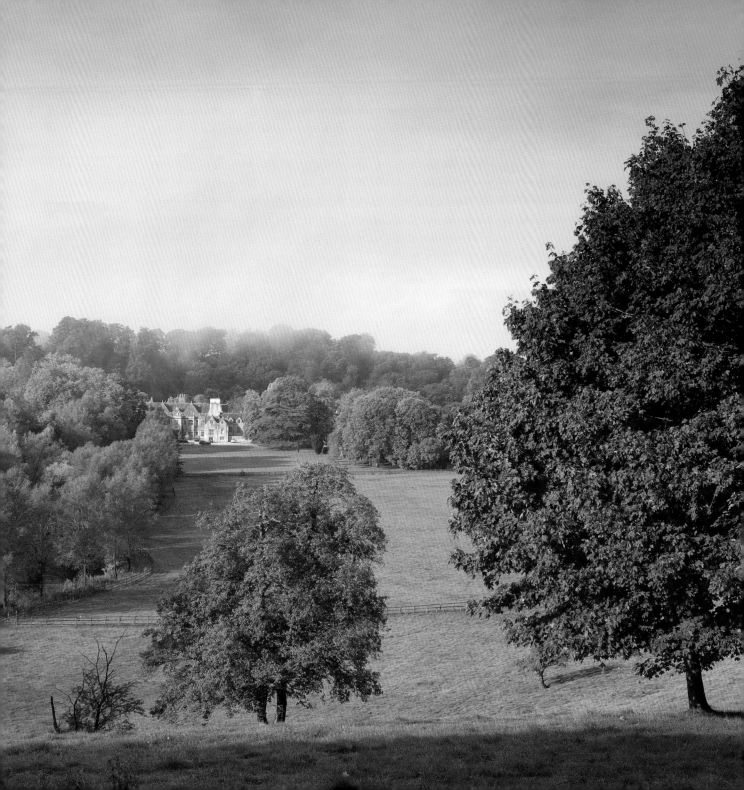

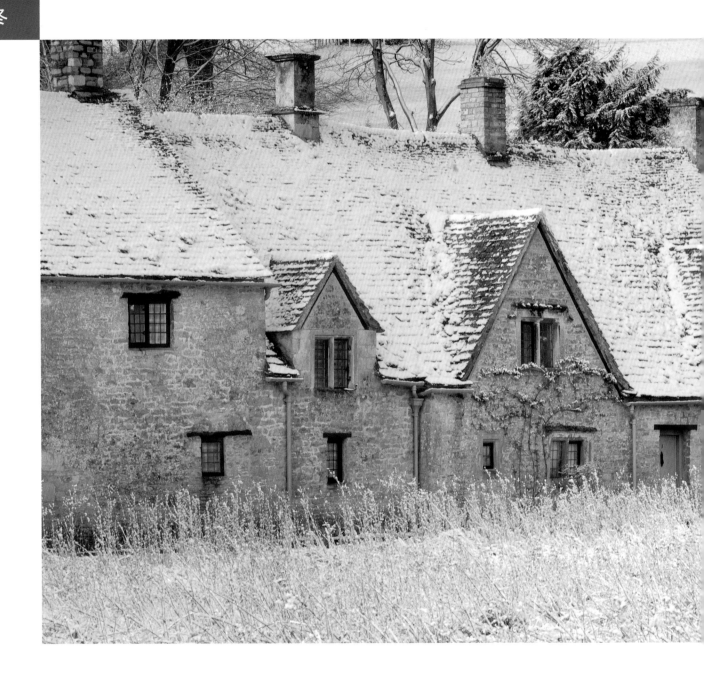

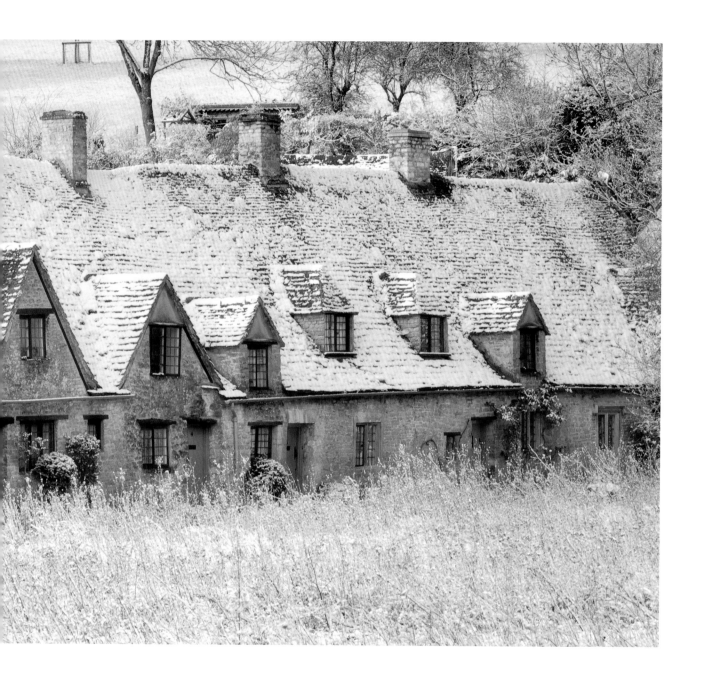

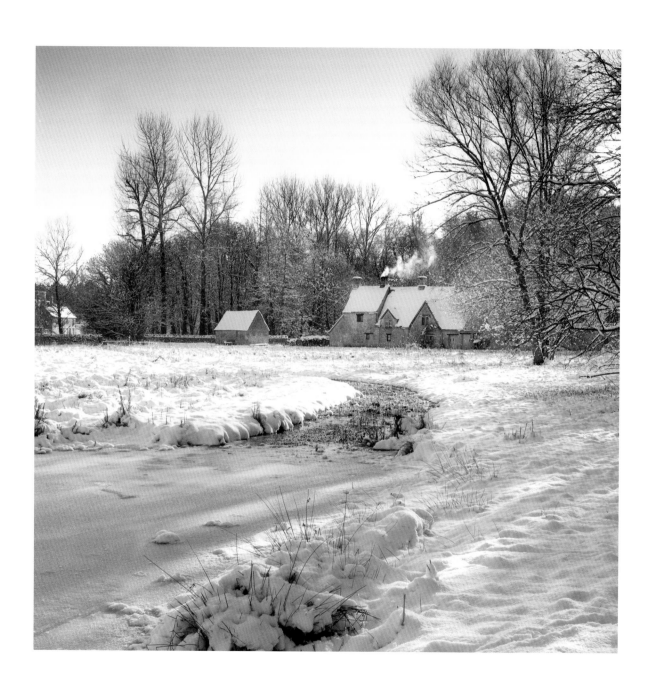

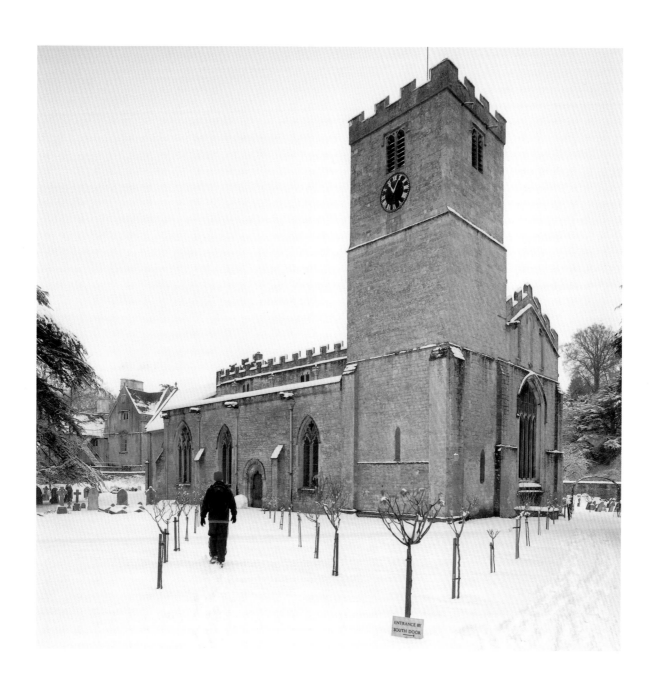

ENTRANCE BY
SOUTH DOOR

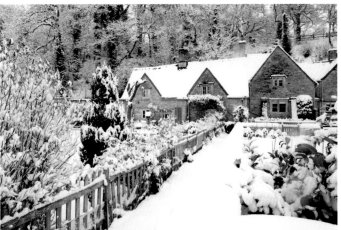

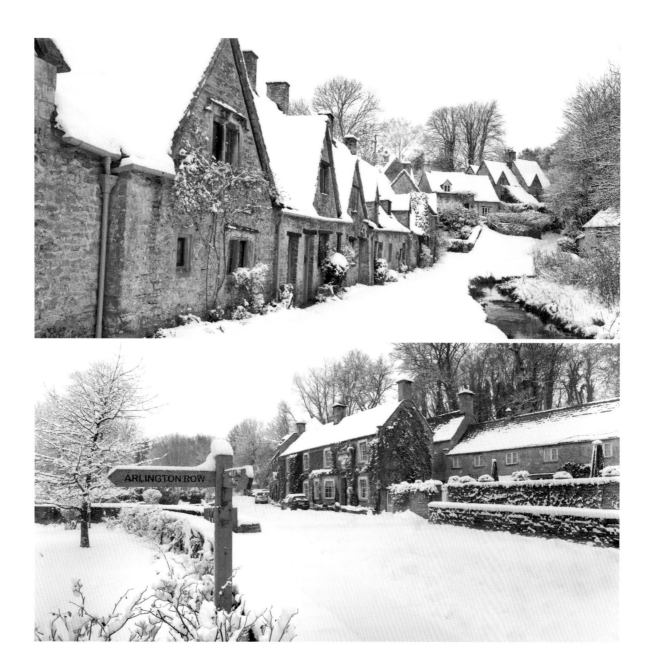

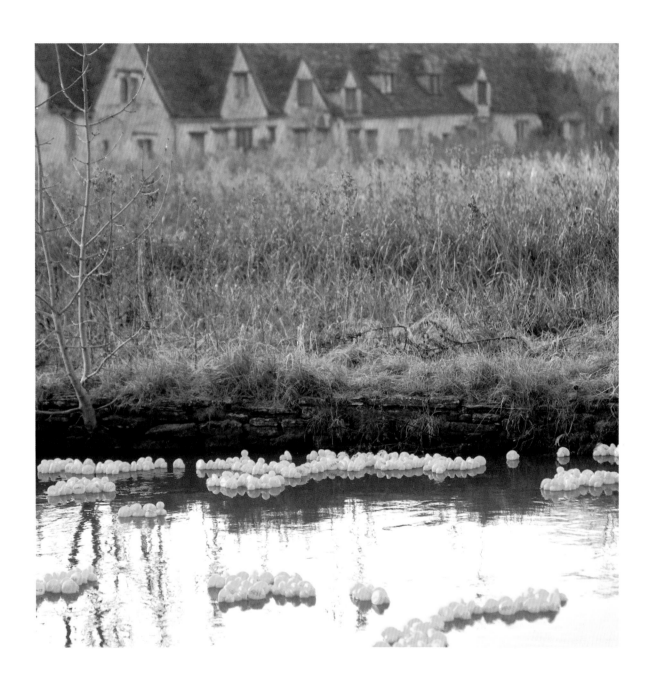

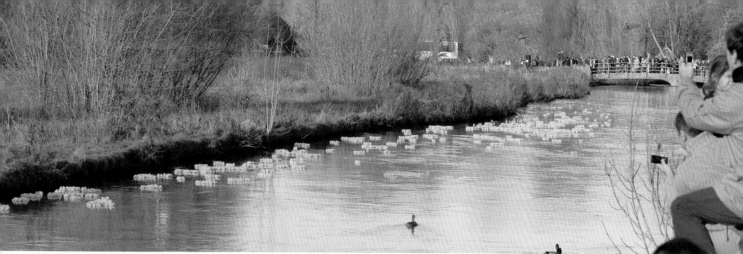

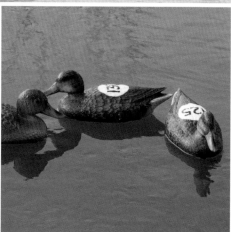

A very British, and some may say rather eccentric tradition, takes place on the river Coln in December. Hundreds of people wrapped up against the chill December weather regularly descend on Bibury to sponsor a duck in the annual Boxing day duck race. All in aid of local charities, a flotilla of decoy ducks bob and weave their way down the river Coln between two bridges, with prizes for the winning ducks.

実に英国的、そしてエキセントリックとも言われる伝統的行事は12月にコルン川で行われます。毎年ボクシングデーに開催されるアヒルのレースでアヒルのスポンサーとなるために何百人もの人々が厚手のコートで身を包んでバイバリーを訪れます。これは地元のチャリティを支援するためでアヒルの模型の集団が2つの橋の間をうねりながらコルン川を下り、勝ったアヒルには賞品が贈られます。

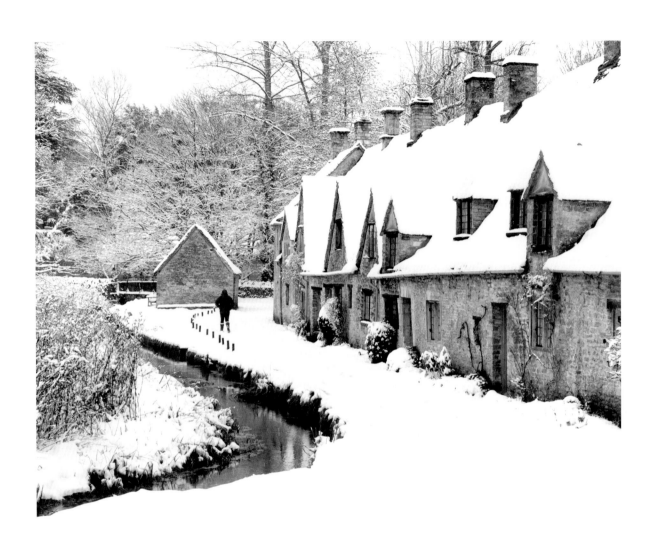

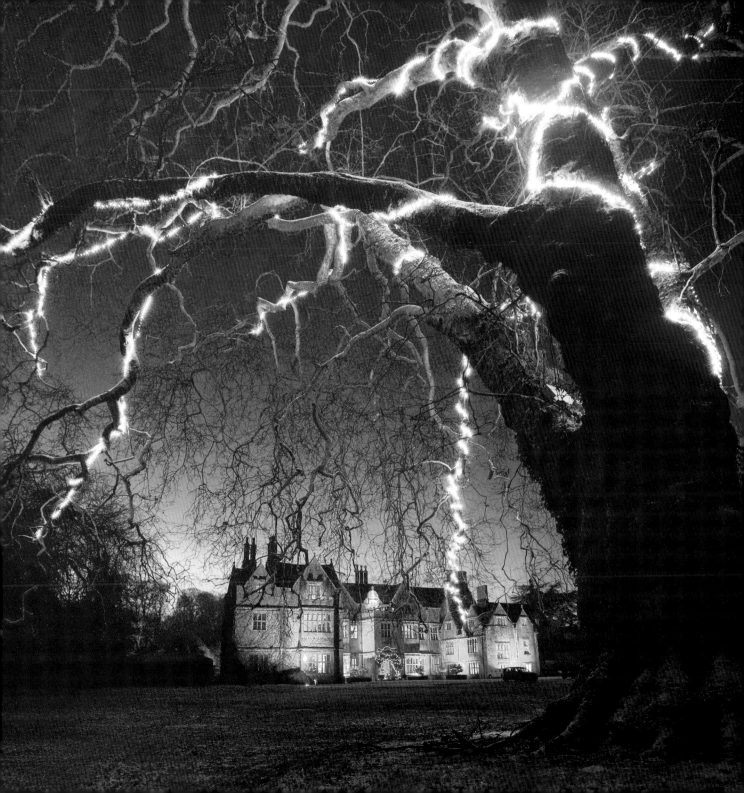

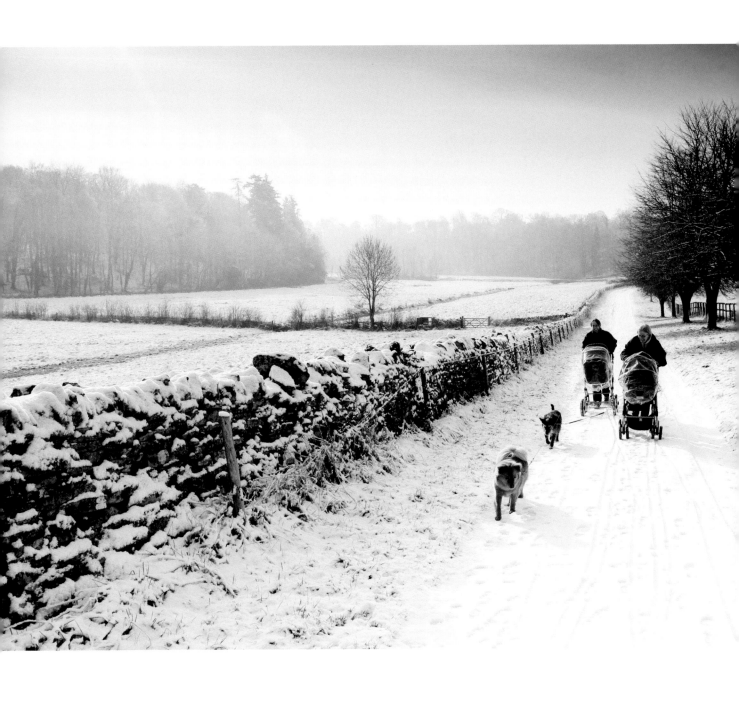

ROYAL MAIL

E R

onday to Friday
4.30pm

er collection is made at **6.30pm**
n the Postbox at
e Lane Trading Estate.
ncester.

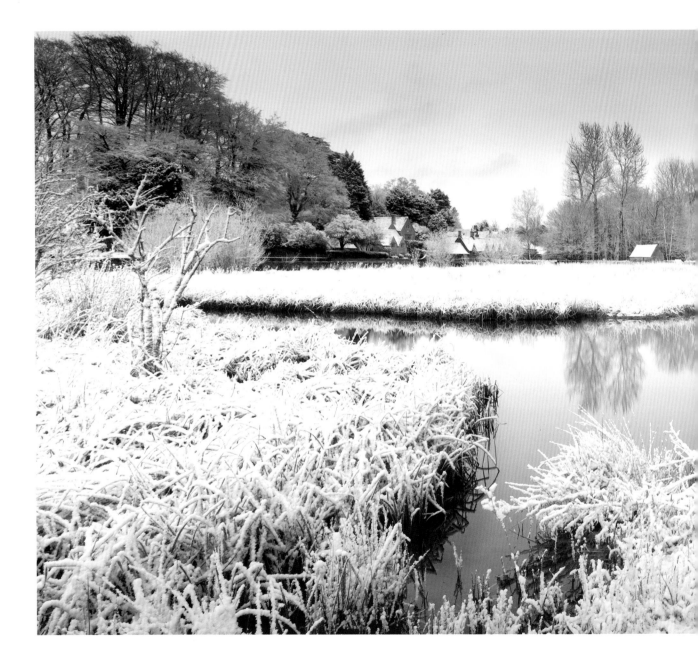

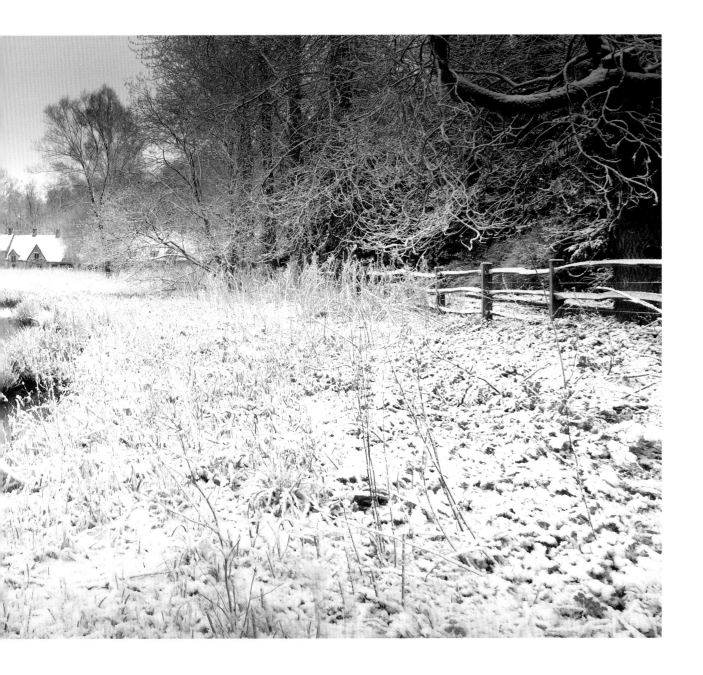

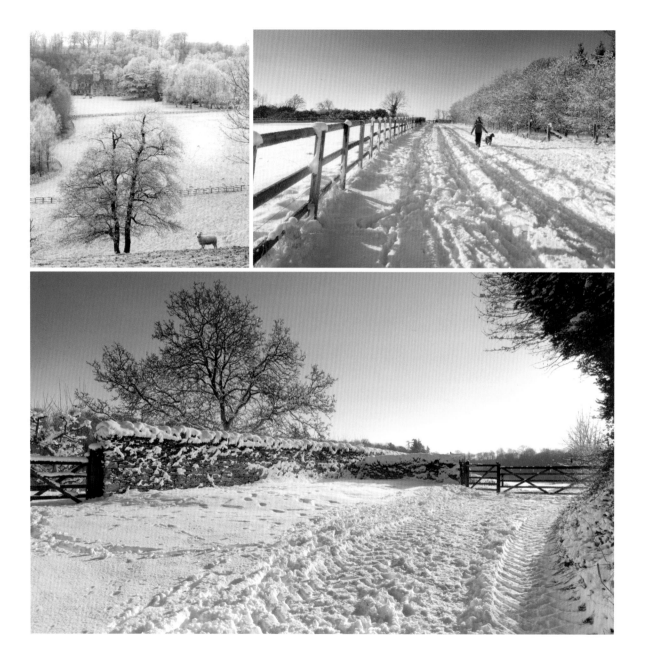

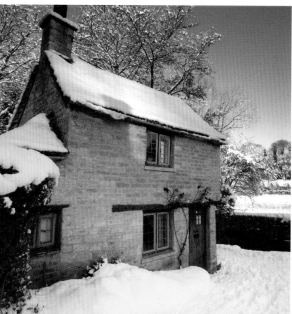

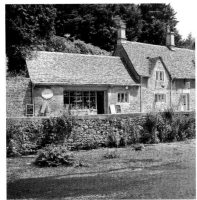

The Bibury Shop & Post Office | バイバリーのショップ＆郵便局

Welcome to The Bibury Shop and Post Office. Here you can learn about the beautiful and historic village of Bibury and also shop for some lovely gifts. You can find us in our traditional, Cotswold-stone building on the main street down by the river.

Tel/Fax: +44 (0)1285 740300 www.biburyshop.com

バイバリーのショップと郵便局にようこそ。ここでは美しく歴史的なバイバリーの村について学び、素敵なお土産をお買い求めになれます。川に近接した大通りの伝統的なコッツウォルドの石造りの建物内にあります。

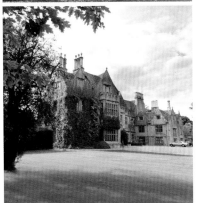

Bibury Court | バイバリーコート

Bibury Court is a stunning Jacobean mansion located in the heart of the Cotswolds. Set in 6 acres of glorious countryside with the River Coln running through the grounds, the hotel offers a two rosette restaurant in which to dine. With 18 very unique bedrooms, the interior is an eclectic mix of traditional old world grandeur mixed with new cutting edge design. A perfect country retreat.

Tel: +44 (0)1285 740337 www.biburycourt.com

コッツウォルドの中心にあるジェームス一世時代のマナーハウス。6エーカーの広大な庭園に囲まれ、18室の大変個性的な客室と受賞歴を誇るレストランがあります。日頃のストレス解消、ロマンチックな休暇、近辺の散策、家族旅行など、数多くの目的に適した場所です。

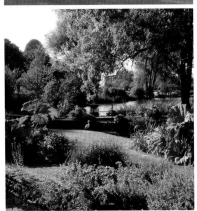

Bibury Trout Farm | バイバリートラウトファーム

Bibury Trout Farm is one of the oldest, and certainly most attractive, trout farms in Britain. Founded in 1902, by the famous naturalist Arthur Severn, to stock the local rivers and streams with the native Brown Trout it now covers 15 acres in one of the most beautiful valleys in the Cotswolds, the Coln Valley. The crystal clear waters of the Bibury Spring provide the essential pure water required to run the hatchery which spawns up to 6 million trout ova every year.

Tel: 01285 740215 www.biburytroutfarm.co.uk

英国最古、そして最も魅力的なマス養殖場の1つ。地元の川や小川にイギリス産のブラウントラウトを増殖するために1902年に有名な自然主義者、アーサー・セバーンによって設立され、今やコッツウォルドで最も美しい渓谷、コルン渓谷に15エーカーの地域に及んでいます。バイバリースプリングの澄みきった水は毎年最高6百万の卵を放卵するマスの孵化場の運営に不可欠な純水を提供しています。

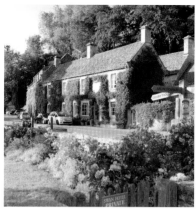

The Swan Hotel | スワンホテル

The Swan Hotel is an enchanting 17th century former coaching inn sitting in the heart of the village on the banks of the River Coln. It is the perfect retreat for unpretentious comfort, a friendly atmosphere, wonderful food and fine wine. This is a superb spot from which to explore the Cotswolds or for a romantic break, a wedding, a celebration, a trip to the races or a place to discuss business.

Tel: +44 (0)1285 740695 www.cotswold-inns-hotels.cols.uk/swan

スワンホテルは村の中心のコルン川の川沿いに建つ17世紀の馬車亭を改装した魅惑的なホテル。コッツウォルズの探索、ロマンチックな小旅行、ウェディング、祝賀会、各種レース観戦または会議に最適の場所です。

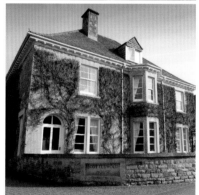

Cotteswold House | コッツウォルドハウス

Whatever the occasion, at Cotteswold House you can enjoy the welcoming comforts and attention to detail of our 4-Star Bed & Breakfast and Self-Catering accommodation. Situated in Bibury, described as the most beautiful village in England, Cotteswold House is an ideal centre for exploring the towns and villages of the Cotswolds and surrounding areas.

Tel/Fax: +44 (0)1285 740609; www.cotteswoldhouse.net

4星のB&Bと自炊設備のある宿泊施設はあらゆる目的に対して快適さときめ細かいサービスをご提供します。イングランドで最も美しい村と呼ばれるバイバリーにあるコッツウォルドハウスはコッツウォルズの町や村、周辺地域を探索するのに最適な場所です。

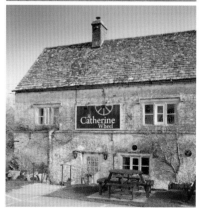

The Catherine Wheel | キャサリンウィール

There's always a warm welcome in our family-friendly 15th century Cotswold stone building with lounge bar, restaurant, accommodation and garden. It's the perfect place for a refreshing drink, a meal, a private function or a wedding party.

Tel: +44 (0)1285 740750 www.catherinewheel-bibury.co.uk

家族向きの 15世紀のコッツウォルズストーンの建物にはラウンジバー、レストラン、宿泊施設および庭園があります。お飲み物やお食事、ご宴会・会議、ウェディングパーティに最適な場所です。